We can stand by the brig-foot and see
 the bright things
On the sun-shining water, that
 merrily springs
Like sparkles of fire in their mazes
 and rings.
While the insects are glancing and twitters
You see naught in shape, but hear a
 deep song
That lasts through the sunshine the whole
 summer long,
That pierces the ear as the heat gathers
 strong
And the lake like a burning fire glitters.

John Clare

The works:

cover – Self-portrait, 1887

1 Road with cypress and star, 1890
2 Tree roots in sandy soil, 1882
3 The Potato Eaters, 1885
4 Orchard surrounded by cypresses, 1888
5 Café-terrace at night (Place du Forum), 1888
6 Flowers in a blue vase, 1887
7 Olive grove, 1889
8 Wheat field with reaper and sun, 1889
9 Fresh grass in the park, 1890
10 Storm-beaten pine trees against a red sky, 1889
11 Old man in sorrow, 1890
12 Bridge at Arles (Pont de Langlois), 1888

The Littlest Books Collection

The Littlest Book for a Joyful Event
The Littlest Book for Every Day
The Littlest Book for Just for You
The Littlest Book for Mother's Day
The Littlest Book for the Heart
The Littlest Book for Your Birthday
The Littlest Book of Bears
The Littlest Book of Birds
The Littlest Book of Castles
The Littlest Book of England
The Littlest Book of Herbs
The Littlest Book of Ireland
The Littlest Book of Kittens
The Littlest Book of London
The Littlest Book of Mice
The Littlest Book of Monet's Garden
The Littlest Book of Scotland

The Littlest Book of Small Things
The Littlest Book of The Twelve Days of Christmas
The Littlest Book of Trees
The Littlest Book of van Gogh I
The Littlest Book of van Gogh II
The Littlest Book of Venice
The Littlest Book of Wales
The Littlest Christmas Book

Images © Kröller-Müller Museum
© 2003 Ragged Bears Ltd.,
Ragged Appleshaw, Hampshire. SP11 9HX.
All rights reserved
Printed in China
ISBN 1 85714 272 1

for CHS

The Littlest Book of van Gogh I

Edited by Janet Shirley

Ragged Bears

With many thanks to the
Kröller-Müller Museum
and especially to
Margaret Nab for the idea.

O that my heart were awake, O God,
 To see the glory of thy handiwork.
 Thy visible works are
 The joy of angels,
 The delight of cherubims,
 Heavenly treasures.
 When thou hadst laid the foundations
of the earth, and accomplished the
creation of the world,
 The morning stars sang together and
all the sons of God shouted for joy.

Thomas Traherne

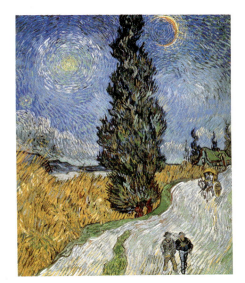

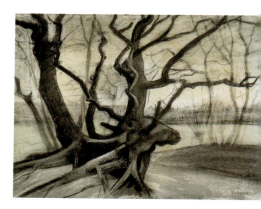

There is a beauty in the trees peculiar to winter, when their delicate slender tracery unveiled by leaves and showing clearly against the sky rises bending with a lofty arch or sweeps gracefully drooping. The crossing and interlacing of the limbs, the smaller boughs and tender twigs make an exquisitely fine network which has something of the severe beauty of sculpture.

The diary of Francis Kilvert, 1874

What astonishing sketches! Dismal processions under grey skies, the common grave; views of fortifications with right-angled perspectives; La Galette mills with ominous sails, and besides all this a misty dark northern fog; then unproductive gardens, twilit roads and peasant women with African eyes and mouths...
I was struck dumb in this chaos by poor people eating a meal in a sinister hut in the dull light of an overhead lamp. This he called The Potato Eaters, it was strikingly ugly and disturbingly alive.

Emile Bernard, 1891

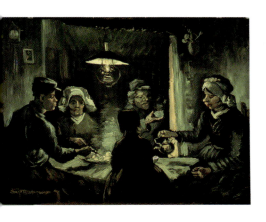

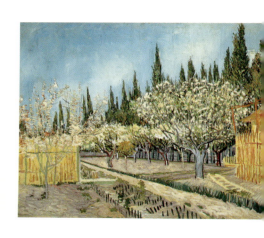

I'm doing nine orchards: white, reddish-pink, blue-white, hazy pink, and one's green and pink. I sweated at one yesterday, a cherry tree against a blue sky, the young leaves just opening were touched with orange and gold, against the green-blue sky this was absolutely glorious. Unfortunately there's rain today, and I can't get back to it.

van Gogh to Emile Bernard, 1887

Once, in finesse of fiddles found I ecstasy,
In a flash of gold heels on the
 hard pavement.
Now see I
That warmth's the very stuff of poesy.
Oh, God, make small
The old star-eaten blanket of the sky,
That I may fold it round me and in
 comfort lie.

T E Hulme

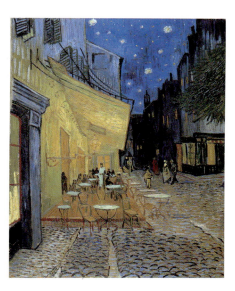

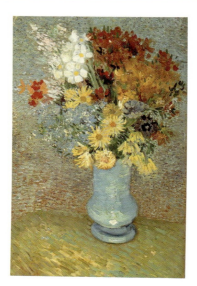

Now thin mists temper the slow-ripening beams
Of the September sun: his golden gleams
On gaudy flowers shine, that prank the rows
Of high-grown hollyhocks, and all tall shows
That Autumn flaunteth in his bushy bowers;
Where tomtits, hanging from the drooping heads
Of giant sunflowers, peck the nutty seeds;
And in the feathery aster bees on wing
Seize and set free the honied flowers,
Till thousand stars leap with their visiting.

Robert Bridges

'Go to dark Gethsemane
Ye that feel the tempter's power,
Your redeemer's conflict see,
Watch with him one bitter hour.'

J. Montgomery

Vincent van Gogh, deeply religious, said
that he painted olive trees as if himself in
that Garden.

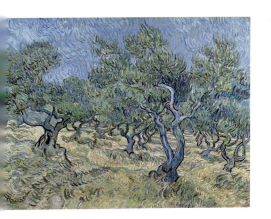

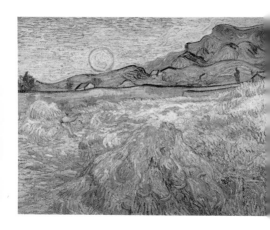

'Painters,' said van Gogh, 'have a duty to paint the richness and magnificence of nature. We need cheerfulness and happiness, we need hope and love. The older, the uglier, more vicious, poor and ill I become, the more I long to balance this by producing brilliant colour, well-composed, resplendent.'

letter from Arles

Study Japanese art, look at a truly wise man, a philosopher, intelligent, and what is he doing? Discovering how far the moon is from the earth? No. Examining Bismarck's policy? No. He is studying one blade of grass. And this blade of grass leads him on to draw all kinds of plants, the seasons, the landscape in all its aspects, and after that animals and humans. These fill his life.

letter to Theo, 1889

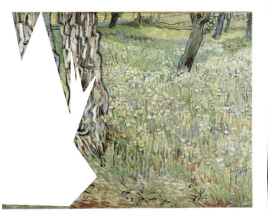

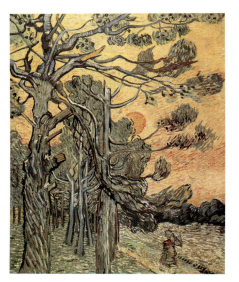

The storm is over, the land hushes to rest:
The Tyrannous wind, its strength fordone,
Is fallen back in the west
To couch with the sinking sun.
The last clouds fare
With fainting speed, and their thin
 streamers fly
In melting drifts of the sky.
Already the birds in the air
Appear again; the rooks return to
 their haunt,
And one by one,
Proclaiming aloud their care,
Renew their peaceful chant.

<div align="right">Robert Bridges</div>

Ever blooming are the joys of heaven's
 high Paradise,
Cold age deafs not there our ears nor
 vapour dims our eyes;
Glory there the sun outshines,
Whose beams the blessed only see.
O come quickly, glorious Lord, and raise
 my sprite to thee!

Thomas Campion

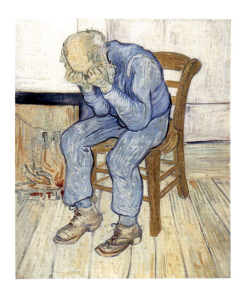

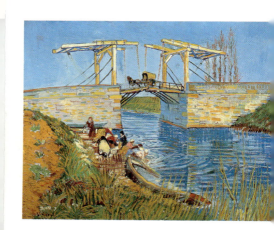